D0966632

wildly into the dark

typewriter poems
and the rattlings
of a curious mind

tyler knott gregson

A TarcherPerigee Book

tarcherperigee

An imprint of Penguin Random House LLC
375 Hudson Street
New York, New York 10014

Most TarcherPerigee books are available at special quantity discounts
for bulk purchase for sales promotions, premiums, fund-raising, and educational needs.
Special books or book excerpts also can be created to fit specific needs.
For details, write: SpecialMarkets@penguinrandomhouse.com.

ISBN 9780399176012

Printed in the United States of America
1 3 5 7 9 10 8 6 4 2

Book design by Elke Sigal

sly

introduction

We are back here, here where we started. We are back here, again, to simplify and expound upon, to reduce down to what matters most. When I was asked to jump into this strange pool of publishing for the third time, I knew what I wanted this book to be, and I knew what I wanted to feel when I picked up the book that would be created. I wanted to simplify the format while showing the changes that I have undergone since *Chasers of the Light* was introduced to this crazy world. I wanted to show the way my writing, too, has changed. I have always been rubbish at reading my own writing, at knowing what value, if any, the poetry, photography, or captions held. I still do not know, and so in choosing the content for this book, I trusted my gut and I went with what felt truest to who I am today.

We live in a society that puts perfection on a pedestal. There is pressure, everywhere, to look a certain way, like certain things, and spend our time filling tiny squares on social media with reflections and representations of that perfection in our lives. We are told to strive to share snapshots of some curated life, frozen moments that forget to tell the bigger story. The truth I have known, longer than I

haven't, is that we are not always surrounded by light and light alone. There is darkness, and there are dark days; there are storms as often as there is sun. Perhaps for me, art, and the creation of it, has been reduced over the years to the pursuit of accurately and honestly reflecting both sides of that reality: the shine of noon and the pitch of midnight.

We are back here, here where we started, and I am still and will forever be a chaser of the light. This will not change; it cannot. This book, this third dip into the pool, shares the same heartbeat as the first, only stronger. We are back here, again, and now I know that sometimes, in order to chase the light, we must start running, lending our laughter to the echoes, wildly into the dark.

I was born to see it, all
of it, and I cannot fathom an existence
in which I do not cross the borders
and wander into the waiting hands
of so many different worlds.
I was born to be held
by strangers arms under
stranger's rooftops, if for a time;
I was made to be sung to sleep
by foreign voices
singing foreign lullabies.
Will the stars look the same,
will they shine brighter,
will I?
Bring me to the far off,
the sun soaked or storm scented,
bring me to the dark clouds
over emerald hills,
the moss on the rock,
the sky blue, then mostly
white.
Bring me to them,
and with me,
joy.

We will wake to the road, the ribbon of black
stretched and winding North.
We were made to do this, there is a reason
our toes point forward, and we will find
what others before us gave up for lost.
Carry us wind, drift us across borders
and let us settle like dust;
where will we accumulate?
Come with me, hold my hand and wander
off the map, into the rest of what lives
out beyond this, into the untamed
pieces of world. Let us find the solitude,
the perfect solace of standing quiet
in the great expanse, just stand with me.
You are the only one I know
that feels as good
as alone.

I will be the silhouette in the
window light, if you'll be
the indentation in the mattress.
Some mornings, you will
rise before me, some,
I will count your breaths
as I pull shirtsleeves down arms,
and force my face through the neck
of some clothing I will wish
I was not wearing. Be the light
through the ceiling fan,
I'll be the squeak of the
reading lamp as it is
pulled closer;
be the shower steam, and I'll
write your name
on the mirror.

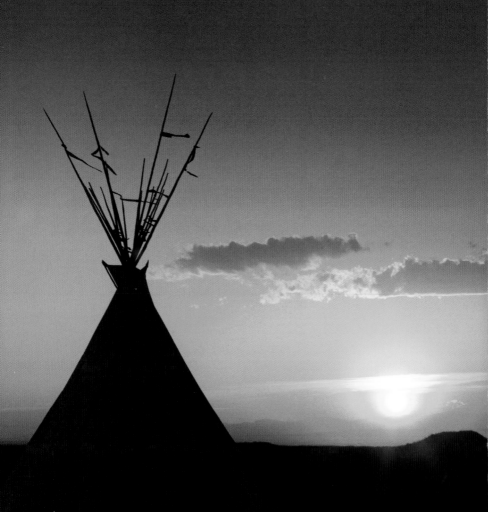

There is magic out there, so it's magic we'll
seek. Adventure lives a whisper beyond our
comfort zones, just a half breath after No
turns into Yes. Here's to the wild life we will
never stop living, here's to the wanderlust
and the light we were born to chase.

There are words others know that translate things we don't know
how to, single words that speak to paragraphs of meaning,
and I need to learn them. What do I call the way it feels when you
spread goosebumps across my skin by hovering your fingers
above it? Is there a word, somewhere, for the loneliness
that comes in the first weeks after losing a treasured thing? There
are times your throat swells and tears feel unavoidable
and cresting the horizon of your emotion, what do we call this?
I've heard of the words that describe longing for unnameable
things, blank aches for vagaries of vague originations.

How many syllables belong to the word that attempts to encompass
the feeling of spotting the one you need across a crowd, a sea of
wrongs and one lighthouse of right? Are there ways of describing
your feet when they cannot run fast enough to close that gap?
I deal in words, they the paint to the blank canvas of each page
I am given, but I do not know enough; I am overwhelmed with
how little color I have, how little hue, to paint the landscape
of this life.

If I do not follow you
out of this zone of comfort
I've lived safely inside,
Push me, pull me, or
throw me from that
circle. If my wander loses
its lust, if the soles of my feet
begin to rust, if I forget
the way to adventure,
force it upon me until I
remember; demand a life
five thousand shades
from ordinary.

I will love you in memories, and the memories will be
many. I will love you in the dark wood under
bare feet, the familiar squeaks in worn out pieces
of floor. I will love you in the smells of breakfast,
of coffee, floating up the stairs to sleeping noses;
I will love you with midnight eyes and morning voices,
soft humming to fevered heads, dances in circles. I will
love you in the places we've been and the pieces
of ourselves we've left behind along the way, the
half torn stubs to fully used tickets, the pocket
softened passes from planes boarded, the
sand in the suitcase we discover months after
our return. I will love you in lazy Sunday afternoons
and groggy Monday mornings, in exhausting
Wednesdays when Friday seems two lifetimes away.

I will love you in open windows with gentle breezes,
in stormy nights where the lightning lends shadow
to the goosebumps on your skin. In the long drives
down old roads, the mapless mornings, the
arms out windows surfing the air that blows by,
in the stamps in passports, in the weeks we never
leave the house. I will love you in promises, kept,
and even those broken, though they will be few.
I will love you in the walks, in the runs, in the
sweat pouring down backs for a dozen reasons,
some sweeter than the rest.
I will love you in the steam, rising,
from the mug. In the mug, casting circles on the
table, in the table, built with aching hands from
the stage so many stood atop, danced on, sang, spoke
with clarity and purpose. I will love you
in all they tore down, and all that we saved
from disintegration. I will love you in forgiveness given
and apologies accepted, in long conversations about
hard topics, in the gentle understanding and tenderness
that comes only with respect. In the respect that comes
only when it's reciprocated, and often. I will love you in
the moments fresh from a shower, unadorned, simple,
and exactly perfect. I will love you in the sheets, bare,
and clinging. I will love you in pieces, singularly kissed
and worshipped for being as they are, always. I will
love you in memories, to be made, and made thus far.

I will love you in memories, and the memories will be many.

It's ok to find art in completely ordinary places. It's ok to make it when you can't find it. It's ok to see the world in a way that makes you feel lucky to be in it. It's ok to be in love with every single thing around you. It's ok to wait. It's ok to hurt. It's ok to feel joy pulsing so fiercely through your body you can hear its heartbeat out loud. It's ok to not be able to find patience to get out of bed each morning you are so excited to live. It's ok to lie there and wish you never had to leave the sheets. There are no wrong answers here, no rules beyond this: Be kind to everyone and everything, and give yourself away. It's ok.

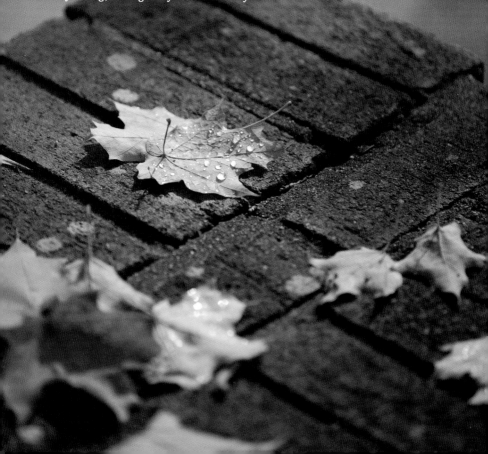

I was walking, slow, but walking,
and the ocean was above my knees.
I didn't know of the cold that crawled up
or the mist that hung silent above the surface.
I knew the darkness, old friends since longer
than we'd both admit, and I knew the waves,
in ways I promised I would not explain.
You found me there, walking, slow,
but walking, and you called out to me.
I do not know how deep I would have gone
if you did not know how to pronounce my name.
Do I thank you now, drop to my knees
in the shallow waters and kiss the salt on your shoes?
Do I tell you of the deep and the soundless I
was headed for? I will speak to you
with the sea on my lips, and leak salt
of my own when I offer gratitude
for saving what was left of my life.
I was walking, slow, but walking,
and you called out to me. Thank you,
through the mist and the waves,
thank you, for the lighter fabric on me,
the water line you stopped no higher
than my chest. My heart never felt the cold,
my lips never tasted the lightless far below.
Thank you.

Don't you want a face
canyon carved
and eroded in smiling places?
Don't you want hair
snow colored
from all the hours spent
outside our comfort zones?
What of legs weary
from wandering feet
and curious eyes?
What of bed frames with
claw marks left behind,
like signatures
of passion?
Will you feel shame
for wanting to suck every drop
of life
out of your days, every
ounce of joy
from the years you were given?

Love is a peculiar creature, how it flows out of us and leaks into the cracks and fractures of the life around us. How it can grow. Expand. How it can encompass so many things that fill up our lives, the people and the animals, the moments and the adventures. We are born to love, built for it, and that ability is always there beneath the surface, no matter how buried we think it becomes, no matter how much we forget. We are put here to love, freely, and I have just begun.

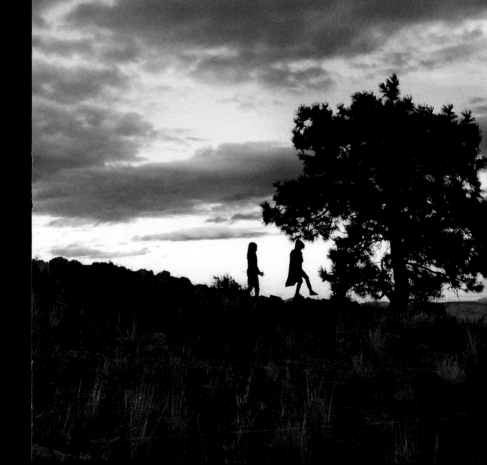

Will I have taken these for granted, these moments,
this life? Will I reach the next beginning, and
carry regret into the new light, the first light?
I was gifted a million opportunities to appreciate
this blink of an existence,
I will promise myself until these knees are bloodied
and my tongue is swollen, that I will live
with eyes opened wide, and a heart
that never closes. There is no where else to start
but here, I have no more time left to waste.
For the thousands of moments waiting,
I see you, and I will cherish you
as you've always deserved. Forgive me,
please Forgive me, for every unappreciated
second, for every time I forgot
to thank you outloud.

They could come for months, stay for
years, decades or more, and still
I would remember less of them
than I did after the first glance of you,
the first time our skin grazed
each others. Some spin through
our days like an unheard whisper,
they fall away with just the
dull sensation that someone,
somewhere, was saying our name.
Some are the open mouth scream,
inches from eardrums, the voice
that leaves us hearing the beat
of our own hearts inside.

Oh tender heart, oh sweet
and unsettled soul, patience,
patience indeed. Long has there lived
an aching inside, a throbbing
dull and constant, a pull to
all that comes after this,
across the darker waters,
the beauty beyond.
It will come, and you to it,
and the heaving of the hull
of you will settle;
you will sail.

Meet me here, I know I am sinking,
I know the water is night black
and starless with shadow.
Meet me here, though the shore is soft
and your feet are dry
and you'll never need to fear
the dark waters.
Meet me here, here in the depths
of all this,
for I have been waiting,
legs churning the ink
of these lonely waters
to keep my mouth high enough
for you to hear your name
shouted into the sea
between us.
Meet me here, wade out
and finally swim to me.
I will love you on your shores,
but only here, in the bottomless,
can I hold you.

For one moment in my short little blip of a life, I danced with her. She reached her lily-white fingers out and I took hold. For one moment, this little me was connected to the great big everything. A crooked line from the soil to the sky, and in between, me, glowing.

Lightning came,
white hot and flirtatious,
she was all hands,
I was all she saw.
I know now, scars sunken
and heart beat slowed,
struck but surviving,
I must have been
water all along,
for sand would melt
into glass, and glass
is born for breaking. I
know now, battered and
tossed aside far too often,
that I am the unbreakable,
I am the electrical charged
but still flowing river, I
will wash it all
away.

We are told from infancy, from the days
spent staring up at all those we
tried to understand, that love was,
and is, and should always feel
like coming home. These wandering
years, these nomadic months spent
above clouds and far from the
walls that hold me, and now I
know, love, actual and honest love,
is the joy of running far away, into
the wild beyond, and in the
delirious peace that comes only
with adventure, glancing at the horizon
and seeing home, coming to
you.

The laces, untied, the socks won't
match. I won't know what to wear
and when to wear it and I
am rubbish at the small talk required
to fit into places I've never bothered
to fit into. There are square pegs
that spend their lives trying to squeeze
into round holes, but I wasn't even
given four straight sides, I am shapes
when none are required, I am
a million wrongs stuffed into
something I never asked if it
was right. I am this, and I've
never been that, I've no plans
to remedy the broken bits.

I will breathe more, but be more thankful for all of those who are capable of stealing it. I will listen more, and absorb the words being said with a clear heart, and a mind that is not conjuring up my responses. I will hope, more hope for more things that seem hopeless. I will be the last one to let go with hugging arms when someone trusts me with an embrace; I will be strength when it is needed, but always decorated with simple tenderness. I will be the holder of wild things and the soother of soul sickness, I will be the magic you stopped believing in, the jaw-dropping reveal that you would've sworn was an illusion. I will be the hand you hold, but we can take turns leading one another into adventure. I will be the shoulder for crying, the fingers for tear drying, the lungs for sighing, and the wings when yours are too tired for flying. I will be the answer if you are brave enough to ask the question, I will be the end of the sentence that begins the most important paragraph. I will be the words, for I have always been the words, and all of them will be true.

They will learn one day,
after too many to fall before,
that words are stronger than ever credited.
That the bold black of typed text and stained fingers
from honest words leaked on simple pages --
is braver and can shift the balance of power and
promise and catalyze courageous change more
than the blood red stains on tired streets,
the bullet shells of censored thought
and misunderstood gospel or confused canon.
That the sound of poetry will echo louder
than rushing feet and screaming voices
and explosions shaking morning prayers.
Don't we know by now, don't we see
that their god is your god and yours is mine
and we all will die with the same bruises
in the same spots on our knees;
kneeling, we are all the same distance
from whatever heaven we believe in.

hot springs

"Have you ever seen this many *j*'s, *v*'s, *k*'s, and *h*'s in words before?"
You smile that smile that comes only when your eyes are lit up from
somewhere beyond us; that smile that comes when you see me for
the first time in the morning, when you wake up from a nap and I'm
still there, and when I close the car door behind you and you know,
with certainty, that we are driving off together. The flight here
scared you, more than you'd care to admit, but the white in your
knuckles and the cling to my arm have betrayed you. It was beyond
windy and the turbulence did a lot more than rise and fall. We made
it, to this place that feels like it is another world entirely, and never
before has an island felt less like an island. The best idea you've had
in the last, well, forever, came when you planned for us to stop at this
hot spring as the first and only "planned" excursion on our entire
adventure. You thought that after the strain and stress of getting
here, the flights and airports and delays and baggage claims, both
of our bodies would not only need a rest, but need each other with
far less clothes than we usually get to enjoy. Watching you emerge
from our rental car, rusted and a color that looks like it used to be

blue, in nothing but your bathing suit and a towel draped over your shoulder, I could not be happier that we did plan something. This is the first I've seen of your swimsuit, a surprise that you insisted on keeping until, I suppose, today. You look like a movie star from the forties, the polka dots holding their shape on your hips and the straps decorating your shoulder blades perfectly and with more delicacy than I deserve. There is steam everywhere around us even though we haven't found our feet to the water yet, and walking towards me makes patterns left behind in the wall of white; monster cutouts crashing through cartoon walls.

They call this place the "hot springs plains" and after wandering around here in the daylight hours it isn't hard to see why. On both sides of this amazing place are glaciers and in between are all of these natural hot springs pools, some too hot to go into, others not hot enough to keep the chill at bay. The one we've found is perfect and after filling in this bedroom-sized hole in the earth the hot water filters its way out and finds its way into the much colder water of tiny streams and tributaries that lead down the valley towards the ocean far in the distance. The effect of that much warmth finding that much cold makes an audible hiss and it sounds like we're sitting inside the sound of a tire losing air, of a hot-air balloon filling for the first time, of a television channel stuck on static. I love it.

Once in the water that I tested first—I'd rather my skin boil than yours—you slide over to me somehow without disrupting any of the water around you. Not a bubble or a splash, not a sound or a ripple that found its way from you to me. It's as if when in water, you become it. It's as if the water doesn't wish to disturb you, so it parts and lets you through without consequence or restriction. Your legs

find their way inside mine under the steam that hovers above the surface and your hand wraps under my arm and around my back. The water is just deep enough that if you try to stand up, it covers your nose, so I am your support today. Silently your legs wrap around mine and I start half-wandering us around the pool. The rocks under my feet are smooth and hotter than the water they sit in and this causes me to do a little dance step with you clinging to my torso. Your hair spills behind you and when my feet find a rock that is higher than the rest, it rises from the water and decorates your back, new patterns each time, all perfect. The stars can be hard to see through the columns of steam that rise around us, but every now and again when you arch your back far enough, letting your ears dip into the warm water, the steam breaks for just long enough to see them shine. There are more here, I don't know how, or if that's even possible, but there are just more. They burn brighter and they shine longer and they never vanish into your periphery when you turn your head. It's as if they come out for us and to remind us that their light took so long to come to us, that if we never had the patience to wait, we never would have seen them here, tonight, like this. That as much as it hurts, sometimes it's all you can do: wait, endure, and keep shining, knowing that eventually, your light will reach where it's supposed to reach and shine for who it's supposed to shine for. It's never easy, but it's always worth it. You lift your head from the water and kiss me. I taste the water on your lips, filled with heat and mineral, and kiss you back.

Me, the man on
the mountain,
the lightning rod
closer to the heavens.
Me, the whisper
into the dark places
outside the walls,
inside this skin.
The blind walk into
the pitch and lightless,
the comfort found
on the cloudy days.
Me, the hermit
on the hillside, the
soundless scream
to the valley
below.

Let's go in search of hidden gems close to home.
Let's sleep under skies and wake with campfire
smoke lingering in our eyes. Let's watch the light
fade and erupt with color before darkness comes.
Let's grab the keys and feel the road spill out in front
of us, disappearing into the rearview mirror all we
have endured. Such magic is waiting, such splendor.
Find it with me now. Now.

Color comes before the blue,
it throws purple and pink
onto the mountains,
on the trees, and sometimes
on me. In the Summer months
this window of light lasts longer,
we are gifted more of that paint
stained sky.

I walk the dogs in the nights,
simple loops under first stars,
under storm clouds. I see
my own footsteps left behind,
I see the new ones I leave.

Are we not the children
of the time we're given,
the ants that scurry when seen
from a great enough height?
My path crosses yours
from time to time,
of that I am certain.

I have a few promises to offer you,
the believing is up to you, the
proof will emerge, but I cannot
say the when. Here is what I have,
my sincere offering, scar earned and
burned into me:
when you think you can't, you positively
can, when you think it's over,
it may be beginning. There is always more
to find, always something left in you
when you would swear on your soul
you've been emptied out. Finally,
and most exquisitely important,
I promise you it is worth it,
it is always worth it, every drop of
ache and sorrow, every perfect pinch
of joy, it is worth it. Promise me you
will keep waking up, keep finding it,
and finding the strength in you
to believe me.

I will stand here,
patient, under new trees
that flower over old bones,
and wait for you to come
to me.
I will walk there,
slowly, and listen to stories
of last words spoken
to first loves,
as my feet float over them
on my way to you.
Maybe here,
they will whisper to us,
maybe here, they are laid out
like a xylophone for our feet
to gently play.
Years from this night,
when the rains have gone
and the chimes are still and quiet,
under new blooms those old ghosts
will tell new stories, our story,
and our love will haunt them.
We are everything,
and we have always been.

Let the ghosts rise and teach us to dance, let them teach us how to let go.
Let the goblins crawl out and teach us of darkness, let them teach us how
 to love it too.
Walk swift, you rested now rattling bones, return to those you have lost.
Let them teach me of patience, let me learn of endurance.

Don't come to me with a flimsy boat
and expect my seas to calm.
I am tornadoes on churning oceans,
water spouts in black clouds
like fingers of a god stirring
his coffee, black as night.
I am a raging storm contained in flesh,
and you cannot love me in a row boat.
Come for my lightning, come for
the way my thunder will hold you
in a way no one else ever could.
Don't come to me with your maps
and star charts and facts about the wind,
set your sails and we'll end up lost
together, for I know not where
these gusts will blow.
Stand on the bow
and raise your arms like an offering,
have no fear of the rain in me,
have no fear of the dark,
for I will cradle your ship
like an infant thing,
and give you home
in all the raging.

"I cannot sleep
without you
anymore,"
you said, soft and lost
in my tired arms,
"Nor I, without you,"
I said, the weight of your
head on my chest.
We are built to be one,
one thing in the dark hours,
one breath rising
into the ether above us.
Move closer, still closer,
until no space exists between us,
until this skin becomes
that skin,
and all I am is shared
with all you are.

You were the smell
of the first fired wood stove
at the first crisp
of Autumn. You were the smell
of Spring's first rain. You
were the orange glow
of a night snow in the dead
of Winter, you were the
sleepless night before
a Christmas morning.
You were Summer's first thunder,
and final flash of
lightning.
You were, you are,
all I've ever looked forward
to.

I will never be
the first
of so many things
for you. I came too late,
after life and love
were woven into the
tapestry
of your existence. I care not
about lost firsts,
but I will fight, knuckles
bloody and teeth sharpened,
for your lasts.
Take the old firsts
and put them to rest,
silent below the dirt
and ash of all the new ones
we will burn through.
Take them, but
give me the
lasts.

Let yourself live the life you were born to live.
Stop affording yourself the excuses you were
taught to make for reducing the adventure and
pursuing the sedentary. Stand up, tall as trees,
and wave farewell to the reasons to be afraid.
There is magic to be found, and you were built
for the searching. Go.

I want a life measured
in first steps on foreign soils
and deep breaths
in brand new seas.
I want a life measured
in Welcome signs,
each stamped
with a different name,
borders marked with metal and paint.
Show me the streets
that don't know the music
of my meandering feet
and I will play their song
upon them.
Perfume me please
in the smells of far away,
I will never wash my hair
if it promises to stay.
I want a life measured
in the places I haven't gone,
short sleeps on long flights,
strange voices teaching me
new words to describe
the dawn.

Let my name leave your mouth
as gentle as smoke, as early morning breath,
curling and rising, dancing before it vanishes.
Hold it in your lungs like the same,
let it stain sweet taste on your tongue
and gift calm to your weary mind.
Let it sketch and paint on the canvas
of all your thoughts, let the sound of it
bring trees and green hills and the stones
of old streets washed grey with new rain.
See the letters of it on the backs of your eyes,
let them find new orders as the bold black
identifiers on foreign plates living on foreign cars.
Speak it to me, softly with aching on your tongue,
and every piece of me will be yours.
Say it aloud, flavored with the pride that comes
with choosing, the confidence that piggy backs
and comes along when you are chosen.
Let my name leave your mouth, often, gently,
and listen as yours floats from mine,
we will say them until they sound the same.

I would trade the lights,
all of them spread out
soft and winking
like they had my secret
and were constantly letting me know
they'd keep it,
for the last flash
in your eyes before sleep.
Take the train songs
echoing across the valley,
the promise they sing
of far off places
and leather boots balancing
on railroad track lines,
waiting for the whistle,
take them and trade
straight across
for a whisper of goodnight
in my almost sleeping
ears.

Convince yourself of coincidence,
tell that sweet little lie
that this hand
didn't cause those
goosebumps
on that piece of your legs.
Imagine if you must, that they don't
dimple that skin higher, that there
are actually pieces untouched
by this spark. I know the truth,
I read you like a novel in Braille,
and you are betrayed by the
chapters I have written.

Fly, I wish, fly from here. This
unmatched silence, this unwiped tear.
Fly, I wish, there's no one near. This
choking emptiness, this breathless fear.
Fly, I wish, fly from here.

Take your sweetness
and bury it deep,
for now is the time
that fire is needed.
Hide the tenderness
in a place you'll remember
to never forget,
for the only fear
that fear will fear
is the wild
running through your veins.
Take your boldness,
your coffee black nerve
and steady hand squeezing
hot coal with not a flinch,
take your bravery,
your sea legs stiffened
against the storm
of indecision,
take your wild,
your bright eyed stare
into the clouds that are coming,
take them,
and nod your head with smirking lips
at all you were afraid
to be.

I think she has roots in the soles of her feet
and when she walks she plants herself into the earth
and lets the earth take hold of her.
I think if you listened close enough for long enough,
you could just make out the sound of those roots in those
soles lifting through the soil, sighing in the sunlight,
and digging their way back into the darkness with each
and every step.
I've met people who are fire, all flame and spark and the
promise of combustion.
Without fail and without doubt I've been burned and boiled
and left with nothing but the residue of the ash
they left behind on my skin.
I've felt the breezes of people who are wind, airy and
light and always drifting. They cool the soul and for a
moment you close your eyes and feel their breath across
your face, but always, always, open them sometime or
another to their absence. They always, always, blow away
and you're left with tousled hair and numbness where they
rested.
I think I am the water and I think I always have been.
I go my own way and somehow, without knowing how, find my
way through the cracks and crevices, the grooves and holes
in the rocks that form around these fragile hearts.
I think she is the earth and has roots in her soles and
leaves in her hair. She curls her toes into the sand and
braces herself against the wind, defiant against the
flames and holds tight to the world as it spins beneath
her. We spin and only she can feel it.
I think she has roots and her roots need water and I am
the water and always have been and know and hold the
secrets to sinking beneath the soil to give strength to
the growth that's been waiting to come.
Some people are fire and some are wind
but we are water and earth and through the roots
on her feet and leaves in her hair she will drink me
and absorb all I have ever been.

I can hear the sound
of her footsteps
now.

We forget so easily that snow, like rain, is made of millions of individual parts. So many tiny and intricate and wildly different parts. We see the whole, the picture created, the blanket of white, and we forget about all the millions hugging each other tightly to survive. I wonder if, far enough away from this planet we roam upon, we, all of we, are the very same.

Take me to our places,
the stones and sticks in the green hills.
Take me to the rooftops made of earth.
The heather and the moss
and the warm rain that makes colanders of clouds and mist.
Take me to the fires that burn out in the night,
the embers dancing from the chimney to tangle with the stars.
The green lights that flow like waves in the cold still air
and the steam that rises from the tops of our heads
as we stay warm in the water.
Take me to the lanterns rising into the black,
wishes carried on flame and fabric,
prayers to all the gods we have never seen.
Take me to those high white peaks,
to the colored flags climbing center poles
and the breathless air we struggle to breathe.
To the mantra painted rocks filling freezing streams
the gentle hands weathered old.
Take me to the swaying trains, the hands on the walls to keep our balance.
the sleeper cars and sliding doors, the crumpled maps in reclined seat backs.
Take me to the cold mornings and the breath that rises,
sunrises on snowy streets, to the coffee in your hands,
to the paint under your fingernails from the logo on the styrofoam.
To the sand covered shores and tide pools that hold the sea,
to the sea that holds the moon and the stars that fall until you sleep.
Take me to our shared slumber in scratchy sheets starched too stiff.
Take me to the cheap hotels and take me to palaces we'll never afford.
Take me to the nights that never end, the lost and wander worn feet
that collapse into bed as the sun is rising.
Take me to the early evenings,
tired legs sleeping sound before the sun falls below the hills.
Take me to our places,
the creaking floors and our boots making songs atop them.
The dim lit pubs and fiddle dances, the globe lights glow,
the hour long talks, the quiet romances.
Take me down the old dirt roads, the rock walls and clover grasses.
To the green and the grey to the blue and the white.
Take me to our places.
Take me to our place.
To the tree that filters the light and scatters it like a kaleidoscope,
to the patterns on your face and the racing of your heartbeat.
Take me to the treelight and teach me of relief.

I just knew I wanted to know
every single thing about you, how
you took your coffee when you overslept,
how your eggs were cooked
when it was you that cooked them. I wanted
to know what woke you from a dead sleep
and what thoughts soothed you
back into its arms. I wanted to know
why you couldn't see what others saw in you,
what you were afraid to admit you have
always wanted. I wanted to know
what songs you sang when you drove
and the windows were up, which
colors you hang in your closet.
I wanted to know everything, but
I didn't know why I wanted to know,
I just knew I had to,
and that I'd be willing to spend
the rest of my life asking the
right questions to hear all those
simple and perfect answers.

Rumble low and bring blackness above me, let it growl and throw shadows all around me. Bring your thunder and bright white flash, I will curl these toes into this soil and stand my ground. There are no winds high enough to scare me from here, no shock I cannot absorb. I will stare into your darkness and show you the light left in me.

 Cleanse me of this sadness,
clear it like dirt
from the grave diggers fingernails
after a day spent singing
to the bones laid still.
 Steal from me this sorrow
rob it like the gold coins
rattling in the old chests,
spill it in the streets
and watch the poor men rejoice.
 You are the thief of untold heartache
and the water to wash it clean.
 You are the bones that sing back
from the soil still unsettled,
 You are the light flickering
from the cleanest side of the coins.

I'm the man who will stop the water,
naked as the moment of my birth,
to save the spider crawling slow
up the porcelain from the flood.
I'm the man who will speak to the
squirrels, or birds, in a tongue native
to the bones in me, and I
will offer out my hand
until the spark in me meets
the spark in them. We are here
but a breath, and we share it
with all that pulses around us,
their lifespan is ours
when spread out across the
magnitude of all that
will ever be.

We were waves, two, from two seas,
set to smash and collide
in the center of the blue.
Our colors and currents
divided with sea foam,
with white stacked
to the horizon.
Watch our water rise
to cloud heights,
watch it fall and spread evenly
across our split.
Here is to the years
we spent waiting,
here is to the miles
we made our way across.
A life spent wondering
how your salt
would taste.

hammock

We both wish we had a camera but neither of us wants to move. The light isn't better than it is at any other time, it isn't more beautiful or even a color that we haven't seen, it just seems that there is so much more of it. Light is everywhere now and we're in the middle of it. The sunshine, or what's left of it, is streaming through the leaves on all sides of us and it's exactly now that I know we picked the absolute perfect spot to tie these knots to these trees and lay these tired bodies down. When a breeze decides to pick up and play awhile, the leaves all move of their own accord; tiny flaps letting tiny beams of light through so that if you cross your eyes just enough to blur the world, there are hundreds of crisscrossing beams of light. They surround us like alarm lasers in a museum at night, like we're the artifact that must be protected at all costs. That we, lying here, are worth more than all the life inside this gallery of trees.

The breeze plays with us too. Us. The cocooned and tightly wrapped us. If it pushes hard enough for long enough it sends us swaying, but

only gently. Sometimes it picks up your hair, holds it high above your head as if analyzing it, and lays it softly back down. Usually across your cheeks, usually requiring my brain to tell my arm to tell my hand to open its fingers to brush it across the side of your face and tuck it nicely back behind your ear. I think the breeze does this on purpose, I think it finds humor, or maybe beauty and love, in this repeated motion and it's curious to see how often it can be repeated, how many times before the action ceases. I am stronger than this breeze, I will not stop.

Lazy conversations between us so often lead to lazy kisses. Of all the kisses we share, I think our lazy and sleepy ones might be my favorite. The heads that turn, but only just enough to meet lips squarely on. The lips that extend, but only just enough to touch each other. The kisses that simmer instead of boil and rather than hint at more to come, whisper that it's just fine to stay this way for now. That kissing, like love, is enough. These conversations, while lazy, always seem to generate the most truth, at least to us. We speak of faraway things, ideas that have not yet fully developed in our brains, wishes for each other that we've not yet shared, but mostly, if we're honest, observations of all that stirs around us. That cloud looks like this, those leaves remind me of that, that squirrel is watching us, this day should never end. We pass the time by not passing it at all, but stopping right in the thick of it and just staring with wide-eyed and mouth-opened wonder. I told you once I loved you for how you saw me, in ways no one does, beauty where I cannot find any. You responded that you loved me for how I see the world, for the exact same reasons. What you don't know is that what

I see in the world is you. Always you. It's your face I see when the sun finds my face, your hair when the breeze picks up, your smile when it starts to rain, and your hands when thunder finally breaks the silence.

My arm is around you and I can feel your breathing change. The lazy words that have been floating out of your mouth for the last half hour have slowed to a crawl, from a crawl to a standstill, and now do not move at all. You're almost asleep and I've no intention of pulling you out of it. You. Perfectly beautiful you. You. The face and soul and heart I've waited so long to finally hold. You. I am smiling without knowing when it started and I can feel my lips vibrating softly as I hum to you. I don't know what I'm humming, and I don't know why, but I am and it's helping you sleep. The hammock below us is holding us above all of this, safe and wrapped, and you're falling asleep. Your entire body is decorated with the puzzle pieces of shadows from the light in the leaves and they move like a living tapestry, a breathing blanket that keeps you cool in the spots the light cannot reach.

Watching the trees and feeling you breathe, it all makes sense. The forest breathes as you breathe. It sighs as you sigh and even the animals going about their lives have grown silent in reverence for the sleep you've been waiting for. They, like I, are watching you and they, like I, never knew that watching you fall asleep would forever change the beat of their own hearts. We are here and as long as the knots I tied hold, I don't want to leave, not ever. Maybe enough leaves will fall on top of us that we will be lost into the forest.

Maybe roots will grow from our backs hovering above the forest floor and plant us into the earth. Maybe the trees will grow around us, through us, and above us and we can put down the worry and fear and let the light shine through our leaves. Maybe one day two kids, young and fresh, will tie knots to our trunks, hang their own hammock, and under our canopy kiss lazily. Maybe, just maybe, those kids will have laughter instead of tears, hope instead of longing, and will never know the sorrow of watching a life be led without them. Maybe they will plant themselves too, grow next to us and listen incredulously at the stories told by two ancient trees that endured the fire and the storm, the waiting and the chainsaws of distance. Maybe, just maybe, their hammock will swing empty next to ours.

I heard you howling
from the depths
of me.
You were the scream
and I
was the still night air.
You whispered from
inside,
the simple truth
that there isn't a priest
with a cross big enough
to exorcise you
from me.
You will haunt
and slam shut,
in the middle of all
my nights,
the doors inside me.
I will count your footsteps
in the cellar of my soul
and beg you
to pass through me
just once more.
Just once.

For such a short time we are here, gifted years by silent explosions in the deep nothing of space. We are the star-dusted blips on the timeline of all things, half of a half of a blink in the history of it all. While we are here we have a choice on how to tumble through our time; we can find every possible way the galaxy has let us down, the pitfalls and terrible defeats, all we believe we do not have, or we can go another way. We can wake in awe and wonder and give our breath freely for all that never bothers to ask if it can take it away, we can chase light and miracles, hiding in so many unassuming places, we can repeat two words like a mantra, no matter what comes: Thank you. Thank you for the starlight that shines inside us, thank you for the moonlight above. Thank you. In an eternity of darkness, this half blink, this momentary blast of color and light, is so much more than enough.

You are here, and more than you know,
you belong. There is more in you
than you ever see, more than the
less you convince yourself of when
the dark pieces of days seem to
outlast the light ones. You are
a soul alight, the flames of
stars and shadows dusted
with moonlight and pitch.
This world cannot spin
without you inside
it.
You are here, and you must
remain.

Love is love
is love
and when time cuts its way
like a river
through the valleys
of our existence,
our brief and tiny knot
on the endless thread,
I want to know that
my feet
knew the damp soft soil
on the right side,
the right bank
of history.
Love is love
is love
and how hauntingly small
are those
that ever place rules
on where it can land
and whose heart
it can fill.

X 624T.

Tell your neck
I am coming near,
I want my lips to feel your heartbeat
and smirk slow when they know
they are the reason behind
the racing.
Tell your chest
to rise and fall and rise
and fill with enough air
to rise once more
once I've stolen
all I can steal.
Tell your hips
I will match their pace
and lose happily the race
if it means tying you
at the finish line.
Tell your toes
to learn the angles
they'll be curling,
I've lips to lend
and skin to send
into constant states
of shivers.
Tell your lips
mine are coming home.
Lost on the road
that winds its way across
your body,
tell them to open slightly
and I'll give back that air
I have thieved.

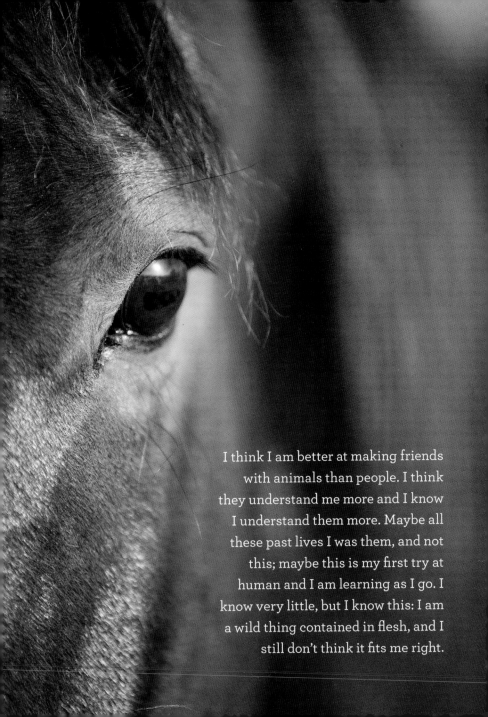

I think I am better at making friends with animals than people. I think they understand me more and I know I understand them more. Maybe all these past lives I was them, and not this; maybe this is my first try at human and I am learning as I go. I know very little, but I know this: I am a wild thing contained in flesh, and I still don't think it fits me right.

It doesn't go, nor is it supposed to.
Sadness has learned
of hibernation
and there are caves buried
in us all.
I will no longer tiptoe
around the edges of its entrance,
I will not douse my torch
nor abide my flames
made smoke.
I will throw it end over sparking end
into the echoing pitch
and the sound of my sprinting feet
will be close behind it.
I will scream it awake
and for now,
chase it from my darkness.

Give to me fire warmed feet
and smoke smell in my hair,
the pillow that will carry it
long after the water
takes it from me.
Starlight unfiltered
and showers of meteors
like assassin's arrows
piercing constellation hearts.
Take the horn sounds
red green yellow glow of
stop start and slow,
burn them to warm us
when the dew freezes,
round and balanced
on the grass blades
below us.
Seek we shall the quiet places,
the pine scented
and the moonlight painted
haunted hallowed spaces.
Hear this heart
as it counts you
to sleep.

Come now storms, come thunder and boom, for
there will be no fear. There will be no quiver or hide
from your threats, no panic at your flashes of light.
Come again and worry not of the scaring you once
did, your path is clear and will go untouching.
Come now storms, and bring your best, for now I
have in me, more rain than you ever could.

You are the sunlight in the long wheat grass,
and I will remember you, smiling.
You gave me years, more that I deserved,
less than I wished for,
and I will remain thankful for them
until mine are up and my number is called, once
again. Was the last light in your eyes, the flicker
before the fade, you beginning again? I feel you
here, fresh and unafraid, and I know you are
saving another life, setting another heart free
by now, by right now. Is this what it is to ache,
is this longing?

I have circled the same path, worn the grasses
down to stalk and dust, and I will continue to.
I am listening for your name, called from a mouth
besides mine, and sometimes I hear it. The wind offering
it up as it carries it over the hills, distant and
still.

I am a swiss cheese heart, holes left when pieces
were taken, and yours may be the biggest. Perhaps
death is the last hole removed, when we are
more air than heart, too many holes in too
many places, the blood doing roller coaster flips
around aortic loops before spilling out and decorating
the dirt. Yours is mine, they mixed long ago, and
I bled as you did.

Thank you, for saving this life and giving me back to myself;
thank you for teaching me, reminding me, and for the comfort
that came effortless and swift every time I knew I needed it,
but more, for everytime I did not know I did. I feel you, and
I will hold your name sacred between my teeth. I know you are
here, new, though you earned never returning again. You came
back, for me, and will see me through.

I will burn the book that teaches me
to sleep without you;
I would rather confetti dance and ash paint
all the exposed pieces of my skin
with its lonely lessons
than settle for a bed still firm
on your side.
Tell the long winded lecturers,
laboring over their lonesome soliloquies
that I will make dust
of their chalk talk, and listen not
to the incessant imploring
that I'll find myself again
all alone.
To the preachers of patience
and their sermons of stoicism,
whisper for them to cover tight
the cups of their communion,
for I will sip the silence they swear soothes,
and spit stain the robes of restraint
they beg me to wear.
Diagnose me, I dare you to diagnose me
all you doctors of diligent dwelling,
for I would rather be crazy
and spend the rest of my life knowing
the sweet song of straight jacket sorrow
than give up the spectre
of a shared slumber.

The headstones, carved and fading,
lined to the horizon like sentries
guarding forbidden places,
the gatekeepers to the after this,
and I wonder. Is there more
to all this than the secret hope
we bury in ourselves that we
will find someone
worth so much that our only
wish, is to die before they do?
I wander through them,
figure eights as I dare not tread
on the slight mounds they
sleep beneath.
I hear them whisper,
I hear them say:
I too was here, I too
felt this way.

Name them, numbered
but orderless, as the stars
fall and burn out above
the palm of the horizon.
Speak softly of the songs
that shaped us,
stand still as the galaxy
emerges, faint as a stain
all but washed out.
Were we the wild dogs calling,
the wolf kin that sang
in the blackness?
Ask, then again, the answerless
question of how we came
to be where we
found ourselves;
release it to the night sky
and let it vanish,
like smoke
exhaled.

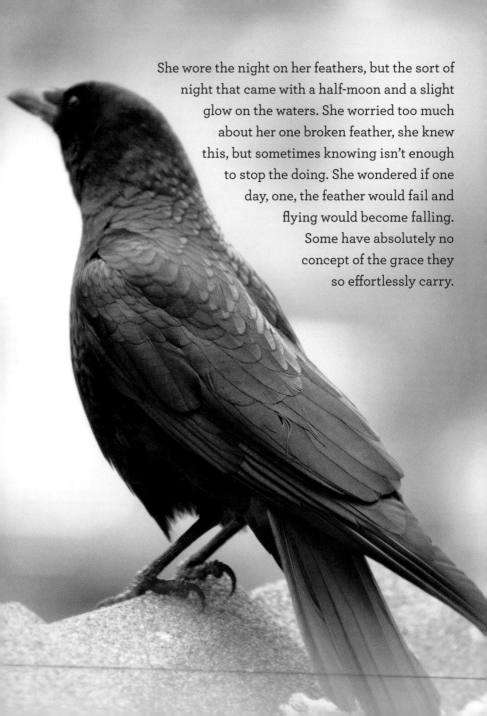

She wore the night on her feathers, but the sort of night that came with a half-moon and a slight glow on the waters. She worried too much about her one broken feather, she knew this, but sometimes knowing isn't enough to stop the doing. She wondered if one day, one, the feather would fail and flying would become falling. Some have absolutely no concept of the grace they so effortlessly carry.

I've never doubted
that I'm a train wreck
kind of man. The metal
and the steam on a
collision course
off the tracks of my life,
I've never doubted
that I will mangle myself
and the land around me.
I will not ask you
to steer clear of me,
I know you would not hear;
I've never doubted
that I'm a train wreck
of a man, but I know
you sit silent in the darkness
and wait for the sound
of my whistle in
the black.

We will die unfinished.
There will be more to do,
to see, say, touch, and love.
There are places we won't visit
and love we haven't made,
there are outbursts of laughter
unshared and tears
that will never fall.
Some plans, some grandeur
mapped out in the minds of us,
will expire quietly,
silent deaths that not a soul
understands. We will pass
incomplete, know this, hear it
and recite it like gospel, like
a mantra of understanding:
We will die unfinished.
Still we must try, we must do,
see, say, touch, and love.
We must find the places and
make the love, explode into
a million fragments of laughter
and weep unashamed. We
must find the adventure,
the grandeur, before
all this goes, and all that
arrives.

Adventure they crave, and me
longing for simplicity.
Wake me, softly,
and with a calendar blank,
bored, look and ask how we
will spend the day.
Planes boarded with stamps
in passport books, feet worn
from uneven streets and
jetlagged wandering;
all I want is breakfast shared,
or the quiet peeling of a book
off your sleeping chest
on a Thursday evening
before the Spring rains fall.
I know the beat of a frantic heart,
of lost and mapless and stained
with the scents of far away,
I know the back alleys of distant cities,
but will you teach me of home?
I want a hand held on moonless nights,
and an ear to share the squeaking sound
of broken wheels on grocery carts.
I want to stop walking around the mattress
to put the clean sheets on.
I want the mundane, and the grand adventure
that lives in finding all that's miraculous
hiding inside it.

These are aching hands, feeling their
age, their overuse from tasks they
never intended on completing, from
years of holding up, months of tearing
down, from pens grasped and
ancient keys slammed home, ink
into page. Trace the scars on the back
of this one, the mistakes that left
reminders, see the fingerprints of the
other, recognize them from what
was left behind on your skin. Know
that I see the calluses, that below them
tenderness awaits, know that aching
though they may be, there is strength
left, there is more than enough
to carry you.

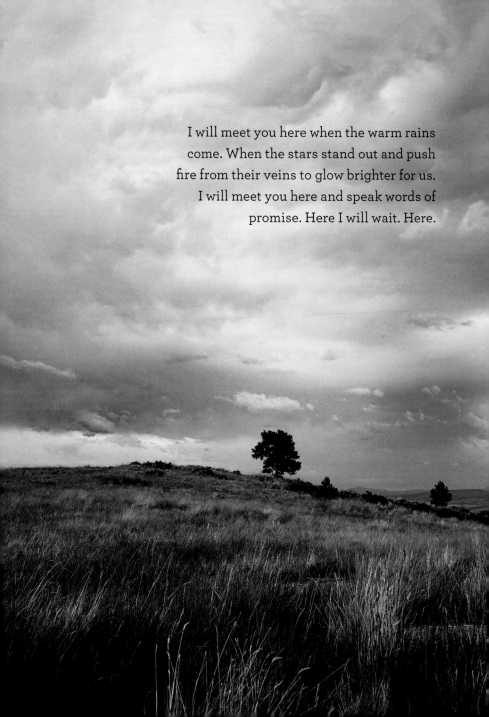

I will meet you here when the warm rains
come. When the stars stand out and push
fire from their veins to glow brighter for us.
I will meet you here and speak words of
promise. Here I will wait. Here.

Don't you know you're rootless,
branch free and not yet
sunken into the soil below?
You can move, walk,
and run forward, you can
plant yourself anywhere
you please, let your roots
wrap around any stones
you wish, strong against the
winds that will strip you
of leaf, of limb. Sing me
the song of your branches
blowing, teach me of
stillness when the storms
have died.

Some growth is done in secret.
No stretching groans
or fingers intertwined
with palms facing the ceilings.
This is a silent sprout,
born in the gathered fabric
of our mistreated skin,
the scar wrinkled reach
to transform all this ache
into something useful.
Perhaps the friction
of all this expansion,
will set sparks dancing
on the flesh it was born on.
I will tell myself, alone and
waiting, that if I was not burning
I would never feel
warm.

What am I to say when the skeletons from your closet
loose themselves of the binds they were wrapped in
and saunter out to dance before me? Am I to hush this
voice, calm the silent rage in me, when they taunt
and tease of the past they rattle for? What do I tell
those bones, time hardened and stiff from the
enduring, when they shake like wind chimes
and haunt the night with their stories? I have two
hands with minds all their own and they crave
chalk from the carcasses in the backs of dark
armoires, dust from the dead eyed and disdainful.
How do I sit calm and listen to pleas for my
amnesia, teach me to forget the sweet flavor
of retribution, that justice cannot always be served,
and I cannot always be the undertipped and overworked
waiter that delivers it. I am sorry for the reactions,
the tears that fall directionless and unexpected,
for the desperation in my eyes when I look for
apologies that cannot fill up my absence then,
then when you needed me most. I will never
hurt those that hurt you, but I will hold you high
enough, that even your waltzing skeletons,
your howling ghosts locked in your brittle walled
prisons, can never touch you again.

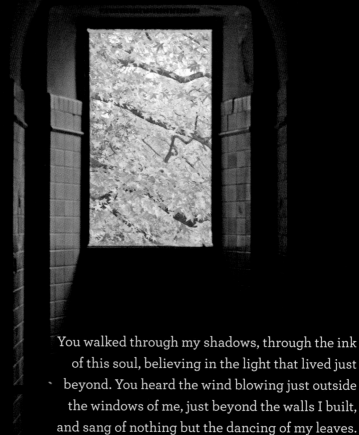

You walked through my shadows, through the ink
of this soul, believing in the light that lived just
beyond. You heard the wind blowing just outside
the windows of me, just beyond the walls I built,
and sang of nothing but the dancing of my leaves.
You chased the shine in me, you chase it still.

It's the over the shoulder glance,
the look back, hair tuck,
corner mouthed grin.
It's the fabric in the fingers,
the hemline the drawstring
the last button to come undone.
It's the tea kettle whistle,
the roll over groan,
the wet lips from soft kisses,
the eyebrow raised.
The lean in, the wandering hand,
open mouthed and eye rolled.
The raised voice, it's the sheets
that end the fights, it's the sweat
for a better reason.
It's the long stare, stolen seconds,
simple flirt with old eyes.
It's the words, it's the unspoken
slow laugh, understanding smile,
it's the hair tuck behind
listening ears.

If it walks, if it swims, if it crawls, flies, slithers, or wiggles, if it grows, if it seeks out sun, breathes in darkness, or wanders around the seafloor, I will love it. If it inspires awe, or injects terror into your blood, if it makes your skin goose-bump in appreciation or your spine tingle with fear, if it cuddles or creeps, if it lives inside soft fur or a hard shell, feathers or scales, leaves or hair, I will stop in fascination and wonder, deep respect and love. If it breathes, beats, or grows, I will wish to hold it in my hands, feel it in my fingers, and lend my energy to it. Always. Always.

You saw the joy in my face
and wondered its origin. I knew not
how to say it aloud, how to give
sound to the sensation, that I
am watching you fall, slowly,
in love with yourself.
I know you lost pieces, acres of
treasured land you kept safe in yourself,
and I know the sound
of the wind in those trees has haunted you
ever since.

I am watching the seeds we planted
take root, watching them grow,
and all that empty space turn to
life again. There is so much
unacknowledged light in you,
and I will never stop turning my face
to it.

I am not wrong to demand
startling humanity, the absolute equality
that was built into us at birth
but was somehow stripped
and stolen away as the weight
of years and lies and the disgusting silt
of prejudice was left undusted from their souls.
I am tired now, worn out from
respecting repulsive ideas from revolting relics,
from excusing beliefs that belittle and abandon
better people than those that believe them.
I have no room left for the right to an opinion
when that opinion places them
on the wrong side of history and the ignorant side
of compassion and love.
It is time now to stop, to stand taller
than those that scream loudest
about their demented doctrines that
decimate entire populations of people.
We are all the same, and we have always been.
We wake and we eat and we walk and we
wander and we wonder, constantly we wonder
if we are worthy of love. We all wonder
the same things, and worry needlessly
about a million more. We. There is no You
anymore, and there has never been a Me.
There is We, and there is nothing more, We.
Throw a stone and it will bring Our blood
to the surface of Our skin, it will bruise
Our cheeks and break Our bones. I,
am not wrong to demand startling humanity,
for absolute equality was built into us
at birth.

Love Wins.

We are covered
in unexploded ordnance,
bombs planted by villains
long since gone. Wires snake
slyly above the sand of our skin,
and so carefully
we walk.
One will come,
suitless and brave,
with fingers like clippers,
and no fear of explosions
promised. One will come
who runs to you,
and not away,
one will come and laugh
at the sounds made
when they safely
detonate,
all we left
for hidden.

Unashamed, I tell you I love wholly,
in a million pieces glued together,
in stories, in memories, in
wishes I gave up for you, smoke carried
from candles blown out, I think it rose
for you alone. I have whispered to you
for ages, across the time and space
and distances that split us; I
have said time and again, I
am here, and every
drop of you will be swallowed.
Parched and tongue blistered
I whispered, I love wholly,
and it is time you
came home.

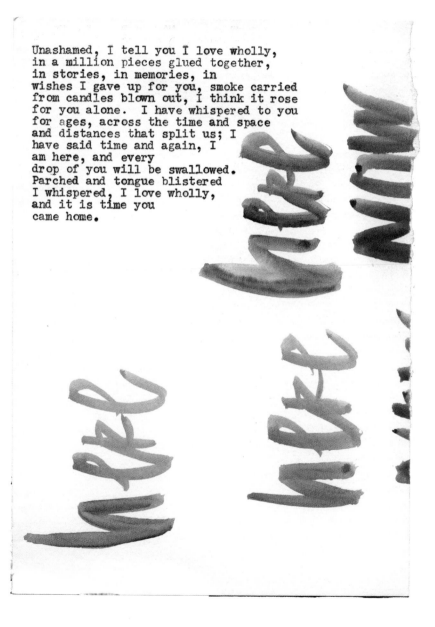

I am waiting for the apologies
you owe yourself,
the beg for forgiveness
to the body that has
kept you alive. Too often
you point your fingers
at the flaws you think you find,
too often you tear down
when you should appreciate.
Tell your legs you love them
for the roads they have
walked you down,
tell your arms
how thankful you will remain
for all they've helped you
carry.
I cannot abide the insults
thrown at the body
that holds you;
each piece is perfect
and deserves
to be told
so.

When the fog rolls in you can fly above it. Never apologize for the strength in your wings, never pretend you don't love the feeling of flight. The fog will come, we are not fated to fall inside it.

What if I kiss all the spots
you taught yourself to hate?
What if I placed my hands on them
and left them still, long enough
for my heat to join yours
and you to forget there was ever air
between our skin?
What if I love all you loathe
and what if I spend my days
dirtying up your brain that they washed?
Show you new pictures of the same you
you started avoiding in the mirror?
What if I say all they say is wrong
and fill your ears with honest words
in a language you stopped practicing?
What if I plant new flowers
in the places that you frown at,
and teach you the names of them
as they bloom?
What if I told you to never cut them
and let the petals decorate the floor
as you twirl through your life?
What if you forget
you were ever anything other
than beautiful.

When the rest of this mind goes, the
cobwebs move in and dangle dust into
the hollow cathedral at the center, some things
will never leave me. This skin I've
worn, carried over the mountaintops and
drug through the darkest valleys,
has no fear of dementia, it remembers
and will never forget. Here is where you
kissed me first, it carries the flavor
your lips left behind. This is the spot
warmed by your hands the most, here
are the scars I earned, they grew in
the waiting. I am covered in
an encyclopedia, verbatim it holds
every breath soaked whisper and
slow dragged promise. When it all goes,
you will remain in every piece
you touched.

They ask me why I write of love,
why all the words are hopeful?
I hear them scream from darker places
that my ladders rise too high to see,
they rest on clouds and one day will fail me.
I whisper back against the voices loud,
the truth may shake but I'll say it proud:
We're all writing about love,
we just don't sound the same.
Boil it down, reduce it to a simmer
and separate it out into parts,
into atoms and the spaces between them,
and it's all the same, your broken heart
is mine and they are both waiting
for the stitches.

nap

The rain on the windows has a mind all its own. It is different than the rain that finds the doors and has a completely different personality than the rain that puddles up on the windowsill below it. The rain on the window plays and it dances. It finds drops to join and it finds ways to paint the pane with its trails. It's this rain that we watch and it's the smell of this rain that is seeping through the screen and riding the cool breeze to us. It's getting colder now, the sweat of summer is fading, but just slowly. It's that time of year where you can't yet smell fall but you know you're about to, it's looming and it's waiting and it's sooner than you're ever ready for. With the smell comes the sound. Slow rumbles instead of hard cracks when the thunder comes back out, the cadence of raindrops on rooftops and drips finding home in puddles far below them. My hand is on your back and your back is under the blanket. I'm tracing circles under your T-shirt, aimless but completely invested. The fabric of your clothing makes its own sound as it adjusts to drape over my hand beneath it. All sounds are soft today, all sounds know the sleep we're trying to find.

Your legs feel cool against mine. I can feel your toes doing the thing they always do before you drift to sleep; they, the rebellious and restless, are always last to calm. They squeeze and they release, they curl and they stretch. If sleep passes in waves through your body, it must leave from your feet after starting in your hair. You are exhausted and the feeling of my hand on your back is letting tiny sounds creep from your lips. I'm not entirely sure if you're aware of them but they make me giggle to myself . . . softly, as all sounds are soft today. Certain parts react in certain ways to the sensation of my hand on them and your shoulders and the sides of your arms always react the most, but only when my arm is completely under and inside your shirt. I feel restricted by clothing, yours especially. I slide your shirt quietly under your stomach, up around your arms, and over your head in the motion I hope will stir you the least. "I want my skin on yours," I whisper to an ear that's connected to a brain that I'm fairly sure is almost asleep. I lie behind you now and the cool of your legs contrasts against the heat of my chest against your bare back.

I can feel my eyelids, like yours, being pulled like old curtains covering broken windows. My eyes burn when they finally close over them. That burn that comes from either crying too hard, leaving them open too long, or swimming without goggles. Today, we know why. The smallest things can affect us in the largest of ways. A walk together. A walk. Your hand finds mine and my knees find the earth. I'm forced to kneel by something stronger than myself, something heavier than the breath trying to fill my lungs. Your hand finds mine and your fingers wrap and all breath evacuates my lungs, fleeing like the last survivors from a sinking ship. You did this to me. You took my hand and the tears from my eyes came with it. And now we

are here, worn out and exhausted and holding each other for life. For life. We've never napped together and for a while you thought I could not do it. You thought the curiosity, the excitement I find in, well, everything, and the never-ending urge to just touch your skin would combine in a powerful index of incompatibility between napping and myself. Usually, you would be probably accurate; today and with you, you are not. With you, I will sleep when you will sleep, but you first. Our breathing is slowing and the rainfall is getting heavier. The sounds of it hitting the roof and the smell of the breeze seeping through the window are lulling us to sleep. I can feel your heartbeat in my fingers inside your hands and you can feel mine on your back, my chest revealing the rhythm of the blood inside me. "Good night, honey," is the last thing my lips remember saying. You answered with a moan and the slightest hint of a smile.

Will I see the fabric billow,
will it blow and carry wind scent
long after the calm returns?
Will it catch raindrops,
the champagne or the white,
the lace from a slower time,
patterns on your skin
from where the light
passes through?
How will it hold you,
how will I, when it falls
like stolen grace
to the floor?

Aren't you ready for kicked-up dust and sunsets that come when the moon used to rise? For the long shadows and sun flares in your hair? For the wheatgrass and cricket songs, for the short sleeves and sundresses? The heat-soaked summer nights are coming, they are coming.

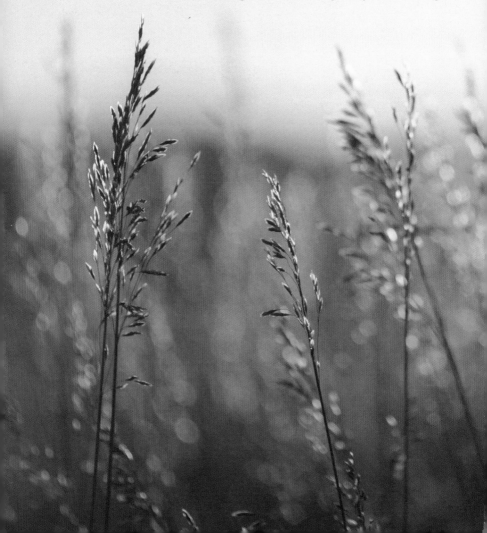

On behalf of the President, they said,
with smoke still hanging in the air
from the salute, the smell of gunpowder,
of rain just beginning to fall through it.
They folded the flag, twice to guarantee
the precision of it all, she saw the need
for the second lap through, I don't think
anyone else did, save him, from wherever
he was watching from. We stood on the
rooftops of other's resting places,
their grass ceilings and dirt walls, and
I could feel them whispering
that they would never mind;
I think they loved all the feet
from all those filled with sorrow,
with celebration, I think they loved
the weight of us. I think they will
cherish what is left of the ash,
the pieces the wind hasn't yet
carried away.

I want to learn of bouncing heads
when they rest on laughing stomachs,
of the ceiling that grows closer
before shrinking away, only to come closer
again when the laughter slows and breath
becomes even once again. The rise and fall
of the life in you and the sea-like sway
that lulls me back to the sleep that escaped.
Teach me of forgiveness,
I want to learn of understanding
by forgetting every night we ever spent apart.
Let the memory wash away slow,
I want to feel them all fade, I want to hear
their death song, clear and bold,
as every unshared moment burns
and stains our fingers soot grey,
the color of regretless joy to come.
I want to learn of your morning sounds,
the stirring and symphonic shifting
when dawn light turns red the screen
of your sleeping eyelids.
Teach me of religion by parting the steam
like a sea, arms spread with hair dripping
as you walk out of the shower
and into the towel I hold.
I hear god's voice every time you laugh.
I have learned of patience, I am an expert
in the sort of aching that seems endless
and I never wish to study the art of longing again.
I want to learn of contentedness, and the effortless
nirvana of never needing to want. I am filled with
so much want of all I need, I am ready for the emptiness
and blank stare at birthday candles for all I need
is all I already have. Listen as I tell you that you,
can have all you have wasted wishes for, you can be
all the things you already are. You are everything
you think you are waiting
to become.

Maybe they are not stronger than me after all. Maybe they too are exhausted and their patience is ready for a break. Maybe the process required for them to reach the heights they have reached reduced far too many of their rocks to rubble. Maybe they too feel the weight of years, maybe they scream of loneliness and frustration, only in a voice we do not understand, a language we do not speak. Maybe I am they and they are me. Weary from the strain and ready to feel footprints upon their surfaces once more.

They asked me what poetry was,
and as few things have,
it stole my speech for a moment.
All I could think to say
was that poetry
is taking an ache
and making it
sing.

I am, and you, too, are.
Strange, we two, oddities
in odd ways, fitting
never happened, never will,
and caring of that lack too,
won't bother to emerge.

I am not like the they, you,
not the them; I am one, and
one, was always you. We will
stay one, even when two,
two ones, stronger than one
made from two halves. Odd,
you, and strange, me...

Let us venture out,
and never worry where
we fit.

Were you born from black top hats,
shared space with white eared rabbits
pulled to fanfare and disbelief? Were you
split in two, sawed in half and stitched
back together again before the lid lifted
and the gasps collected to float above
the stage that raised you? I've no other
explanation for the magic in you, the
illusion transformed into reality you
performed, the moment you met me.
How did you keep the wild inside me ,
while pulling out the fear? How did you
calm me without ever trying to tame?
You took a man, cracked and leaking,
and with no time or bother or need
for curtain or prestidigitation,
levitated him to something more, higher,
wire-free and above anything
he'd been before.

I have iron in these veins, it pumps
fierce through this heart, it makes solid
this resolve. There isn't a damn thing
I cannot endure. Smash it against me
and mourn it as dust when it
floats from my hair. I was never the rock
or the poor man, eternity doomed
to push it, I was the hill, I've always been
the hill, and I will hold.
Listen to the sounds of anvils,
of hammers upon them, listen to the
ringing of metal, every time
I laugh.

Life will keep your secrets, or some, at the very least,
and I will not go digging. What you wish to hold,
will rest sweetly and soft in the palms of your guarded
hands. I will not shake them free. But there are things
I wish to know, some mysteries I want answered.
I want to know how your fingers hold the spoon
when stirring the coffee in the morning, I want to
learn the language of your sighs, fluent in
the morning voice you speak in, before feet find
floors and purpose in their walking, in your waking.
Will you divulge the roadmap to your eyes rolled
in quiet pleasure, the directions, napkin jotted
with pens that break the cloth, to the secret places
on necks and collarbones and the backs of thighs?
Does rose find your cheeks, do veins rise,
does your voice crack when you shout or fight
or scream against the injustices you find? When
the epidemics of situations, the natures of it all,
creep up and in, will fear and worry bleed everywhere,
will it stain us, will protocol protect those who forget
kindness? How do you sing when the shower steam
rises, which foot do you put a sock on first? Do
you fear death, the cold hand black shrouded and
skeletal, do you tremble for what comes next?
Will you love me, more than, above and beyond,
anything you are capable of? W ill you breathe grace
into the pieces of darkness I have carried all my life,
will you lend them your beautiful brand of light?
Keep your secrets, keep me if I should become one,
I will leave the soft dirt atop them, forever if you wish,
but speak to me, shaking voice if it must quiver,
and I will do nothing else, but listen.

If it all burns around you, dance around
the fire. Paint yourself in ash and rain and
celebrate the torching of what was. We can
choose what destroys us, and complete
destruction is never an inevitability. Let
your legs find rhythm to the crackling of
the flames; lend your laughter to the song.

See them as suffering, see them as stained
with the soot of sorrow, buried beneath too many
broken promises, see them as those
too afraid to accept the love they require.
There will be a time to recover the hours they
stole, the lost moments of the lost people,
those that betrayed the grace you loaned them,
there will be a time to use your shaking voice
to explain that their apologies
are no longer needed. They, like we,
like everyone we meet, everyone we see,
are doing their best with what they've got;
instead of being the fist they cringe to,
we can be the hand they reach for.

It is wrinkled sheets
and it is foggy mornings.
The window still open
that forces blankets higher,
cocooning against the chill.
It is the traceable pathway
the warm tea takes
down cold throats,
it is the taste of coffee
on kissing lips.
It is the light through the trees,
the scattered diamonds
on the morning snowfall.
The thunder that shakes the house,
the broken speaker rumble
that follows the flash
and widens our eyes.
It is the held hand under
quiet sheets when both bodies
are sleeping softly.
The smell of home
that clings to the clothes
and evaporates into noses
buried into shoulders
during longer hugs.
It is rainfall on our skin too dry,
restless feet growing still
when they brush against each other,
kicking for comfort
before our eyes
close.

Do you look up from under,
up beyond my chin
into the lower half of my eyes,
a longing look that I
can't even notice?
Am I what you wanted,
more, am I what you
know you deserved,
all those slow years of
silent wishing? I'll keep
these arms around you,
you'll be held tight enough
to forget the days you
weren't; you will forget
the nights before
me.

THE STARS LOOK DOWN

What was this world
before I knew you were inside it?
Did I know, always, before
confirmation came,
did I feel you like a phantom limb,
an ache across the darkness
I couldn't see beyond, did I
wake in the nights, sit up straight
to the lack I knew you'd fill?
Was this an intuition born into me,
did I always know the spin
of the soil below me when you
were away, the slow
when you came near? How did you
make me forget, or was it always
us, orbiting around one another,
waiting to begin again, each time,
waiting to understand.

Who am I to deserve such sights, to witness this splendor? Who am I to be the recipient of such excess? Thank you for trusting me with this color, this light. Thank you for reminding me, always, what lives behind the dark.

These are the days of dirt under the nails,
the hands in the earth and the smell of soil
that lingers in the air when dirty hands
feed tired mouths.
I have waited for this rain, the green
and the white billowing above it all,
the sound of my own footsteps
crunching foreign dirt on far away roads.
What have we found here, what will fall
into the lap of this day?
Where will this head and the body beneath it
find a place to lay?
I will make things rise and feel them grow
and put my own blood into their green veins
if it's my warmth they need to sprout.
I will hold you with mud stained hands
and cover the blush of you
with the slow dragged smears
from my tired fingertips.
You can have all I am,
take the decorated back I'm going to give you,
the lazy swirls that came from a passion
that wasn't lazy at all;
you can have all I am,
take the last drops of rain water
sliding down the sides of my face
and wash us clean.

Did you know you fall asleep with your hand
on your mouth? Has anyone told you
that you sometimes hum in the deepest part
of that slumber? I wonder if you're aware
of the way you smile without realizing it,
the accidental grin that grows, cheshire
slow, until it fills your face so wide even
your ears can hear it? Did you know
you precede any outburst of emotion or
tears with the same sounds, that your
feet hold freeze until long into the night,
and you swim across the bed
to find me like you are drowning
and I'm the last thing left to hold onto?
There is no possible way you understand
the effect you have on those you know,
more still those you love, and allow to
love you in return. You are the center
of the wheel, the sun that
we orbit around. Thank you,
for your warmth.

I raised this silence
from an infant thing.
It was all I had
and I taught it to be ok
with the way it was born.
It grew
in ways I didn't predict
and soon enough
it held me, how I once
held it.
Silence,
I would whisper,
one day you will grow too big,
one day you will go.
Goodnight silence,
I would mumble out
through unused lips;
I got used to never hearing
an answer.
I raised this silence
from an infant thing.
Know this, and make it a mirror
of your worth,
for I would only abandon it
for you.

It was never saving I needed, but reminding.
Somewhere along the way it was lost,
buried deep and covered with mountains
of excuses and procrastinations, a million
reasons to stay where I was, grow roots
from the bottoms of my feet, grow
moss on the palms of my hands, and wait,
for the rest of the world to come to me.
It doesn't, it won't, and alone
transformed itself into the world
that surrounded me, the keyless prison
4 blocks square. It was never saving
I wanted, but reminding. The heart
that slept, dormant like hibernating things
under rock walls that held the heat in,
was waiting for hands like paddles,
a voice like a spark. Somewhere along
the way I forgot of the planet that spun
softly beneath these feet, the people in the places
that needed my face as much
as I needed theirs. There is so much, so many
miracles to find and so much life to live,
there are so many reasons to yawn until those
walls fall down, stretch these aching backs
and wake up again.

Boot heels on gravel, on wood. The walking feet carrying me through long grass, over asphalt and dirt. I will trust you, follow you, and remember the textures you find beneath your soles. Show me the secrets long hidden, take me to the unbeaten parts of the paths. I am ready. I have always been.

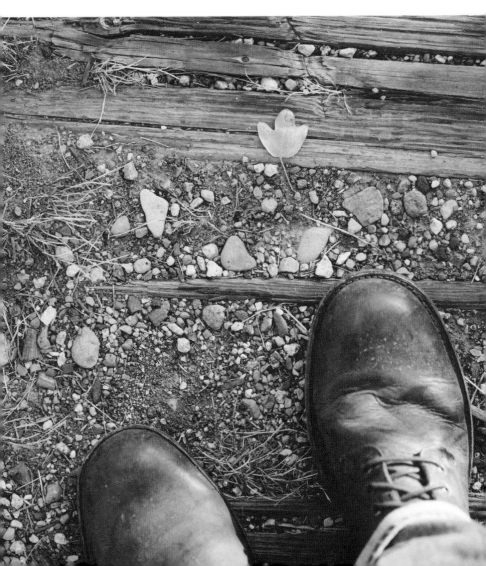

I belong to where I've been,
filled with stubs from tickets spent,
passes of my boarding
and the indentations of me
in the seats I slept in.
I am the overstuffed
but I am the poorly sewn
and the totems from my travels
spill out when I dance.
I am the nomadic collector
of memories and moments,
the sticky hands grabbing
fragments of wanderlust,
and I am hiding them beneath
these ribs.
Follow me, and you may find them;
I leave bits of myself
in the footprints I step from.

pub dance

I'm not used to places like this. Having never drank during the years that most people find themselves inside of cheap bottles, pubs and bars and all places similar mysteriously evaded me, and I them. This place, this small hole-in-the-wall with the original stones and bricks and deep cherrywood tables, this place I can do. The lights are hung around the perimeter of the entire pub; random assortments of old Christmas lights and the larger clear glass globes shine just bright enough to show me the detail of the freckles on your nose. We ran blindly into this place, this place that I tell you shares the name of the first dog I ever loved, after getting absolutely soaked by a surprise rainstorm. "We can't not go in with a name like that," I tell you and you agree with the parentheses of your smile. I have no idea how we got here, I just remember picking southeast as the direction of the day and leaving Dublin at four thirty in the afternoon. We're here now and on this planet, there is no place I would rather be.

When we ran in, the eyes of every person in the room found you. Even with wet hair streaming across your face, even with your raincoat plastered to your skin like it was painted on, you radiate. I

will never forget the look on the old bartender's face when I asked if I could just have a 7UP. I will never forget the squeeze of your hand when we came in here, the squeeze of you realizing that on this planet, there is no place you would rather be either. There are so many things hanging on the walls I don't know where to start. I get lost easily and the music only helps that fact. I can see the reflections of the lights above us in your eyes, still wet with the rain we were caught in. You reach your hand across the table and silently slip it into mine. I love you, you say. I love you, I say.

The floor makes sounds when you shift your weight on it. Like a decaying xylophone, certain boards have certain tones and others are completely silent. We notice this immediately as I take the hand you slip into mine and lead you to the middle of this old dance floor. There are scuff marks decorating the wood below us, remnants of louder nights and faster music. Now, the music slows and I can hear a harmonica start a new song. I pull you into me, and I can feel the water from our skin straining against the fabric between us. Water has a way of always coming back together, no matter what stands between it, no matter the hurdle it must pass. "We are like water," I whisper into your ear as your head finds my shoulder. "What? What does that mean," you ask as you look up from under the ledges of your eyelids. "Never mind. But we are." You, as only you could, understand. We are dancing. I am sure people are watching but I'm only watching you. I know the music is moving faster than we are but the sounds we are making on the xylophone floor together are better. We're alone in the middle of the dance floor and if I didn't hear the sounds of accents around me, I would have no idea there was another breath sharing this place. Your hands are draped

around my shoulders and I can feel your right hand playing with the back of my wet hair. You swirl it between your fingers and let the water slide down the backs of your hands and down your arms. Water always has a way of coming back together. "Can we switch directions, darlin'?" I have to ask during the middle of the song. "I'm getting dizzy." You laugh a laugh that starts in your stomach, rumbles up your rib waves, and leaves your lips and nose at the same time. It's that laugh again, the laugh I dream about and write about and long for. Your laugh of understanding. We're dancing again. Counterclockwise this time, to alleviate the spin and the dizziness. Thank you.

We are soaked and we couldn't care less. The lights, the sound of whiskey being poured into glasses, and the damp smell of wet earth, they are ours tonight. We are dancing and your head fits into my shoulder like the two were one once, pulled and pried apart and forced to be two. Dance with me, just dance with me and tomorrow will figure out itself.

Come near, and we can teach one another
how to treat those who mistreat us.
We can breathe patience back and forth
like rationed breath underwater, shared
to keep two alive when one should've
expired. We can fight instinct and
a natural tendency towards justice
and retribution, we can see through it,
beyond, to the truth. That hurting those
that hurt us only spreads our hurting
further. That only through the delicate
art of truly letting go, can we hold
onto what matters most.
We can watch, we can see like
we were born with psychic eyes,
the ripples that spread from the actions
we choose, we can decide once and
for all, to be the water, and not
the stone, we can absorb the disgraces
and heavy handed blows, and wait
until our surfaces smooth again.

Ruth Gleason

Ruth Gleason
728 N. Benton
Helena

I am ready for the wood floor clip clop,
the boots or heels or wet bare feet,
fresh from the bath. Ready yourself
for the sun's pouring, the Eastern glow
when first light stains us, tangible and
warm amidst the room full of blue.
I will wait for you in the gloaming,
when the sunset pools in from the
Western hills, over the spaces between
where you were, and where you are
now. Let laughter fill these vaulted
ceilings, let rainfall be the song
that drops the books to our chests,
and convinces our eyelids to follow.
Are you prepared for snowfall over the
city lights, for the storms that will come,
outside and in, the lightning flashes
and soul shaking thunder? I've lost
myself in the hollow, tumbled and
spun in the darkness. Life awaits,
and in it, I.

Bring me a cut man, steady hands
still quick with stitch and sew.
I'm bruised and sliced
and these will scar.
Sit me on the stool,
sponge water til the red
runs clear,
I will stand again,
I will always get back up.
Wipe these eyes of the blood
that pooled,
I need to see
what's coming for me.
I will haunch over and gasp
for breath, I will
rise steady and slow,
I will shrug the blows absorbed,
and walking forward,
I will grin.

There's a haze around the thoughts of you,
a soft filtered glow, lighter in the corners
and warm splashed flares that fill the frames.
Were there flowers in your veins,
petal soaked blood that blossomed
across your cheeks?
Maybe this is why your lips tasted of lavender.
Are we the love we have made, are we more
than the breath that rose and the blush that spread
and the shaking hands holding shaking backs?
I never knew memory could come saturated
with texture and temperature and the sensation
of your hands on my skin.
I swear there is a garden in your chest,
I know I can feel you blooming.
I will trace the roots across your flesh,
and I cannot stop licking
my lips.

Couldn't we be great again, once more?
Couldn't we rise above the mess we've made
and be the ones they stand and stare at,
mouths open in awe and reverence, the
green tide of envy washing upon the shores
of their glances? We were once, big and strong
and brave in beautiful ways, the unarmed
big brother, steady handed and tender,
to the little sisters of the world, the courage
to walk away from some fights, while diffusing
the rest with the calm confidence that came
from the struggle endured to become what
we became. We were handouts and hands extended
instead of boot heels on the chests of those
too weak to force themselves up, too starved
to bother. We were the pulling together, not the
pulling apart, the knowledge that the same dust
fell upon us all, the same depression that forced
wealthy men from penthouse windows forced
proud men to wait in long lines for pennies
to protect those they produced. Where did
we forget which Ism to throw faith into, that
no matter how similarly the two are painted,
when sanded down, being a patriot never looked
like being a racist? We were the open arms
to the big seas on both sides, to the oceans
of grass and desert we were sandwiched between,
we were home to the huddled masses,
never the need for castle walls and moats
built to segregate the freedom we forget
doesn't belong only to us. We are more
than the buffoonery and blowhard bullshit
clogging the airwaves and saturating the
evening news, it takes more than a soundbite
to run a country. We are more than the flag we
hold hands over hearts to honor, more than the
trumpets and twilights last gleaming, more than
the pride that seems to unite us only once every two years,
when some sport is played in some far off place, when
we swim faster or score more or stand highest on some
medal podium. We are the space seekers, the star dusted
travelers brave enough to strap themselves to rocket
fuel and hope, we were the first to help, and
we could be again. We are more, and it is time
we were it again.

How is it that I am a million men,
a million different variations
from infancy to this wrinkle-eyed
and sleepy souled ghost that haunts
the places I once knew? I can hear the crack
of some bat on some summer night,
I can smell the grass, fresh cut from
infields, and outfields; I see the shadows
cast on the red dirt and white bases,
before it fades, transforms. I float from
him, ash blonde and sun-stained, to
this, older, weathered by winds in trees
and feet born for wandering, and it
feels seamless. I won't understand
how one soul can be stretched
across decades, over death
and the blooming of it all, but
I am a million men drawing
a million breaths into one set
of lungs.

We are but specks, atoms inside of atoms, the smallest allowed entity to be still called life. We are grains of sand spinning wildly in the deep black of everything, and we never even know we are turning. All we are, all we do, all we see and love and fear, fits inside one glowing pinprick of light on a tapestry of stars. We are but specks, and we have always been. Never once has this stopped us from being monumental. Never once will it. There is nothing we cannot do.

They may ask me to keep this a secret, to
forget to tell you, to spread not these truths
like wildflower seeds into the wind, to
pretend I don't know the colors that will come
if we water them once sown, but I cannot, I
will not.

Here is the truth they stifle, the honest
reality that is hidden beneath all the airbrushing
and manipulation:

You are not your legs, your arms, your stomach,
or your breasts; you are not your body, your flesh,
or hair, you are not the weight you've lost or
gained over the years, over the celebrations
and sorrows, you are not the size of the
outside, but the magnitude of all that
lives inside it. Compare yourself to no one,
not even the person you were yesterday,
you are allowed to shift, to grow, to change your
mind a million times, you are allowed to fail,
because it's only those that put it on the line
and forget about failure, that ever succeed.
You are not your body, say it to yourself until you
don't have to try to believe it, until you let go
of the hatred and angry side glances you give
the mirrors you walk by, until your eyes
become nothing more than X-rays to what
lives beneath. You are so much more.

On this day, new life begins.
Tiny fingers reaching for answers,
empty palms ready for filling.
On this night, so many lives end.
Screams echoing down alleyways,
religion misrepresented,
humanity stained like fresh water
introduced to a drop of ink,
all we see is the darkness spreading,
no matter the dilution, the gallons
of hope watering it down.
We are more than the evil
that leaks in, more than the
fear of the pitch black night
and sounds we wished
were fireworks, but knew
were much more. Keep your guns,
your bullets and your bombs;
We fight with candlelight
and the flowers wrapped in plastic tight,
the moments of silence all added up
to a perfect day of quiet. We
are the gallons upon gallons
of fresh water, the hope ready
to dilute unrecognizable,
the single drops that seek to
stain us.

We are minute, miniature miracles given mere moments to meander this magical place. Forget not you are free to find the fantastic in the fleeting, terrific teeny things in all the temporary. Life is lovely because it cannot last, loss is nothing but the loosening of all the perfectly pristine pieces of the pure and preposterous places we will wander, filled with wonder and wild wanderlust, into. Always appreciate all the amazing and awe-inducing, beg for more breath to borrow, simply so someone or somewhere or something can slide silently in and sneakily steal them swiftly and slyly away.

You'll return as a wild thing, the
un-huntable that roams forests,
and mountains. This transition will
be a seamless one, from tired eyes
to shining; I can already see you glancing
out the corners of them, I can hear
the soft sounds of your footsteps
on the moss.
Did they see your
final breaths rise, did they
see them swirl above you before
vanishing into the dark woods,
before filling the lungs of some new
beast, perfect in its infancy?
Let them hold the goodbyes
on their tongues, let the world
believe you departed, but I,
I will stare into the trees and whisper,
Welcome Home.

Let us go in search
of the rainfall.
Let us find it bouncing
off the cobblestone streets,
raising the scent
of wildflowers to our noses
as we walk down them.
Let us stumble
through green fields
with salt spray
carried on the breeze
to land upon our shoulders.
Let wood smoke rise
and settle into the cracks
of all our clothing,
drying quietly,
and let the salt
leave rings
where it decided
to stay.

I am utterly, intensely, completely, foreverly in love with wild things. How ridiculously lucky we are to live on this planet, under this sun, with so many creatures, wearing so many faces. I don't know who dreamed up everything that grows, I don't know how we all came to be here, now, together, but I will stay thankful every moment of my life.

Walk out with me,
into the light and shine,
hold your palms to the clouds
and show the blue blood
pulsing through your veins
to the sky, watch it hue to
green with envy for the color
you carry.
There is life in you yet,
a heart that thumps wild
and calls for the thunder
to lean close and listen.
There is life in you,
introduce it
to all that beats
in me.

I'll go young, when I go,
and the years tacked on
won't change that. I'll go
shouting, throwing laughter
into the breezes, making friends
with Death despite any
protestations to the contrary.
I wasn't built inside to deteriorate
like my outside pieces, I am
far behind, lapped over and again
by time. It took me years to
understand,
I am insulated by this body,
this shell showing its cracks,
and it will go to ash
when I am but a child
inside, I will not go
quietly, I will go singing
wildly into the dark.

BELL

acknowledgments

This is for the chasers of the light. This is for the believers who never stopped believing. This is for those who have shaped me into who I am today, for those who trusted in this chaos. This is for those who didn't believe, for the fire you fanned in me and for the patience you planted. This is for the survivors, those who kept standing up when all they wished to do was stay down. This is for the helpers who give what they have to those who don't have any, to the fighters of the good fight. This is for those who fight for me, when I don't know how to. This is for the creators, everywhere, and the importance of all they create. This is for those I love, and will always love. For those who push me and challenge me, who teach me and soothe. This is for those who love me back, and don't understand the gift that is. This is for those who trot the globe and discover the world with me and still find just as much beauty in coming home. This is for the chasers of the light, and those who know that it's the darkness that makes that light shine. This is for all the laughter, all the excited screaming, for all the echoes bouncing around all the walls, for the sprinting feet running straight forward, wildly into the dark.

about the author

Tyler Knott Gregson is a poet, photographer, artist, and author of *Chasers of the Light*, *All the Words Are Yours*, and *Wildly into the Dark*, as well as the coauthor of the children's book *North Pole Ninjas*, and lives in the mountains of Helena, Montana, along with his two giant golden retrievers, Calvin and Hobbes. When he's not being struck by lightning or chased by orca whales, he's traveling the globe and always cooking up new tall tales and wild yarns.

tylerknott.com
Instagram: @TylerKnott
Twitter: @TylerKnott
Facebook: facebook.com/TylerKnottGregson
Pinterest: pinterest.com/TylerKnott
treehousephotography.org